MW00449624

re st

*Choosing peace, growth,
and learning holy rest.*

body + mind + soul

Copyright © 2020 by Amy Eaton

All rights reserved. No part of this publication may be reproduced, stored in a retrieval system, or transmitted in any form or by any means – electronic, mechanical, photocopy, recording, scanning or any other – except for brief quotations in printed reviews or articles, without the prior permission of the author.

Scripture quotations marked AMP are taken from the Amplified® Bible (AMP),
Copyright © 2015 by The Lockman Foundation
Used by permission. www.Lockman.org

Scripture quotations marked AMPC are taken from the Amplified® Bible (AMPC),
Copyright © 1954, 1958, 1962, 1964, 1965, 1987 by The Lockman Foundation
Used by permission. www.Lockman.org

Scripture quotations marked ESV are taken from the ESV® Bible (The Holy Bible, English Standard Version®), copyright © 2001 by Crossway, a publishing ministry of Good News Publishers. Used by permission. All rights reserved.

Scripture quotations marked MSG are taken from THE MESSAGE, copyright © 1993, 2002, 2018 by Eugene H. Peterson. Used by permission of NavPress. All rights reserved. Represented by Tyndale House Publishers, Inc.

Scripture quotations marked NIRV are taken from the Holy Bible, NEW INTERNATIONAL READER'S VERSION®. Copyright © 1996, 1998 Biblica. All rights reserved throughout the world. Used by permission of Biblica.

Scripture quotations marked NIV are taken from THE HOLY BIBLE, NEW INTERNATIONAL VERSION®, NIV" Copyright © 1973, 1978, 1984, 2011 by Biblica, Inc.™ Used by permission. All rights reserved worldwide.

Scripture quotations marked NKJV are taken from the New King James Version®. Copyright © 1982 by Thomas Nelson. Used by permission. All rights reserved.

Scripture quotations marked NLT are taken from the Holy Bible, New Living Translation, copyright © 1996, 2004, 2015 by Tyndale House Foundation. Used by permission of Tyndale House Publishers, Inc., Carol Stream, Illinois 60188. All rights reserved.

Scripture quotations marked TLV are from the Tree of Life version. Copyright © 2014, 2016 by the Tree of Life Bible Society. Used by permission of the Tree of Life Bible Society.

Scripture quotations marked TPT are from The Passion Translation®. Copyright © 2017, 2018 by Passion & Fire Ministries, Inc. Used by permission. All rights reserved. ThePassionTranslation.com.

re st

Choosing peace, growth, and learning holy rest.
body + mind + soul

First Printing, 2020
Printed in United States of America

Cover and interior design: Nani Williams
Editor: Mytra Layne

Author: Amy Eaton, Chattanooga, Tennessee
Website: LeadingfromLight.com

ISBN 978-1-7363419-0-2 (paperback)
ISBN 978-1-7363419-1-9 (e-book)

Contents

A JOURNEY TOWARD REST

"Are you tired? Worn out? Burned out on religion?

Come to me.
Get away with me
and you'll recover your life.
I'll show you how to take a real rest.

Walk with me and work with me — watch how I do it.
Learn the unforced rhythms of grace.
I won't lay anything heavy or ill-fitting on you.
Keep company with me and you'll learn to live
freely and lightly."

Matthew 11:28-30 MSG

Hi friend,

I am so honored to have on this journey. Over the next few months, we are going to journey toward understanding the concept that rest is holy. I would love to break the ice and share a story with you, if I may...

Wrapping up my tasks to close out a long day at work, I realized I had received a potentially challenging email on a project that seemed to be sucking the life out of me. Unable to resist the temptation, I went ahead and opened the email to discover it was another hurdle. And That. Was. IT! I was so white-hot-mad that I could not leave my workstation and get to my car fast enough. Hands on the wheel, pulling out of my parking space, I angrily told God I was done with my stupid job and this stupid project He has led me to stupidly pursue, as the stupid hot tears spilled out of me like a summer rain. (When I'm mad, I laugh or cry. Crying means I'm furious but not going to go "redneck" in 2.3 seconds....)

I called my husband to tell him about my crappy day, and he seemed perplexed. You see, I love my job, and I was so excited about this project God had given me a lofty vision and passionate fire for! But what happened? Was I really so weak that a few challenges were going to cause me to quit my job, give up on my career, and then spring into the unknown, knowing full well the grass is not greener on the other side? Nope, what I was considering would've been artificial turf or a mudslide.

So, what could cause a woman on fire to want to quit so swiftly?

Exhaustion.

 Exhaustion will snuff out your vision and bury your dreams.

When I realized the weed of my frustration was growing out of exhausted soil, I had an epiphany. I thought to myself, "So, this is why God called me to focus on rest!" He knew these battles were coming. He knew I'd need rest to handle the mental and emotional challenges that were in front of me.

Sister, I don't know about you, but I want to keep dreaming. I want you to keep dreaming. And if you're not currently dreaming, then I want you to begin to dream again. I want you to ask God what He wants you to pursue and then believe that you have the energy and capacity to be crazy enough to do it, no matter how small, insignificant, or crazy big it sounds. He's enough, and you're enough in Him!

Let's chase after Him by caring for our body, mind, and soul as He has so graciously demonstrated for us.

Love in Christ,
Amy

"There's a private place reserved for the lovers of God, where they sit near him and receive the revelation-secrets of his promises."

Psalm 25:14 TPT

"Take some time and be still by the water with your Shepherd. Take a walk with Him. Sit quietly with Him at your table or in your favorite chair. Let the windows in your soul open wide so the fresh breeze of His life can blow in, calm you, and give you rest. Quiet your world, quiet your heart, and just be with Him."

- Jenn Rothschild [1]

"We make time for what we treasure most, and we value most what we believe we can't live without."

- Ruth Chou Simons [2]

"The word of God is always most precious to the man who most lives upon it."

- Charles Spurgeon [3]

As Christ followers, we are called to imitate Christ. Let's consider rest in a spiritual context where it is referred to as sabbath. Jesus modeled God's design for sabbath and rested. He understood that sabbath was holy. Read the Gospels and notice that He would go away with the Father intentionally. Sabbath was not created for God. In Jesus's own words, He explained to the religious leaders that the sabbath was made for humankind (Mark 2:27). God established the concept of sabbath, and He modeled it during creation week when He rested on the 7th day and made it holy (Genesis 2:1-3).

There are many scriptures that reference the importance of sabbath and refer to sabbath as holy. Therefore, we can conclude that rest is both necessary and holy. I would venture to say that it is as important to our well-being as oxygen is to our ability to breathe. We, the created, were called to holy rest by the Creator from the very beginning.

We were and are called to still our souls and rest...

To rest in God;
in truth;
in spirit;
in mind;
in body;
in hope.

"Then Jesus said, "Come to me, all of you who are weary and carry heavy burdens, and I will give you rest." Matthew 11:28 NLT

According to a Strong's concordance reference from BlueLetterBible.org, this use of the word "rest" here is described as "active: to refresh, the soul of anyone."[4] The rest Jesus gives when we come to Him actively refreshes our souls.

When our physical bodies are healing, a necessity for recovery is rest. The same is true for our minds and souls. As people rescued and bound for Heaven, I would say that while we are here, we are healing every day. Every day, we are growing one day closer to our Jesus--one day closer to true healing and release from earthen vessels.

"In Christ, you're a native of heaven right now. You aren't a citizen of here trying to work into heaven. [No, my dear beloved sister] you're a citizen of heaven trying to work through here."[5] - Ann Voskamp [admonition from me]

Until the day comes when we are in our true home (Heaven), let us rest as our body, mind, and soul needs.

Thank you for joining me on this journey of learning to rest. Let's grow together, closer to Him.

Before we begin...

Before we begin this journey together... spend a few minutes alone with Jesus. Be still. Listen to your breath as it flows in and fills your lungs with life and exhales in a lovely rhythm, a rhythm your Creator created within you. Now take a moment to just breathe and just be.

Be right here. Right now.

During your quiet moment, where did your thoughts go? What was tugging at your consciousness, begging for focus?

We're going to focus a lot on God and His Word together over the next 3 months.

> *- During this journey, what do you hope to glean from Him and His Word?*

> *- Take a moment and write down what comes to your mind and heart.*

I want to become more sensitive to God and His whispers. I want to have the patience to make it through the day working for His ~~kind~~ kingdom at my best.

"It is in the empty spaces that you give access for God to speak into your life."

-Danny Hesterly [6]

This month, let's discuss what the Bible says, and what Jesus modeled about caring for the body.

Bible

"But Jesus Himself would often slip away to the wilderness and pray." Luke 5:16 NASB

"Then, because so many people were coming and going that they did not even have a chance to eat, he said to them, 'Come with me by yourselves to a quiet place and get some rest.'" Mark 6:31 NIV

Andrew Quinley (a missionary to Thailand visiting on furlough) shared a message about how the Bible mentions food a lot. You'll find seemingly countless Bible stories are centered around meals. God created your body intricately (Psalm 139:14) and the science of your body is complex, yet simple. Give it what it needs, and it can thrive. Give it things it doesn't need or starve it of necessities, and it will not thrive.

Andrew Quinley's message was a Gospel centered message about inviting others to our tables to "taste and see that the Lord is good" (Psalm 34:8). The Lord also reminded me through his message of how important caring for our bodies is, in even the simplest of ways. Your body is not indestructible. It needs sleep, water, good nutrition, and rest. If I'm honest, and if we're honest, this is typically an area we can all do better with in some regard. Before we chat about that, can we just pause and acknowledge how special it is that Jesus often met people around a meal? We often meet Jesus in places where we need nourishment. Friend, He's pulled up a chair to your table and is hoping you'll pull one up and join Him, too.

"Do you not know that your body is the temple (the very sanctuary) of the Holy Spirit Who lives within you, Whom you have received [as a Gift] from God? You are not your own, You were bought with a price [purchased with a preciousness and paid for, made His own]. So then, honor God and bring glory to Him in your body." 1 Corinthians 6:19-20 AMPC

1. What does the Bible say about caring for our bodies?
 to take care of it to glorify Him

2. How can we be intentional in caring for our bodies?
 give it what it needs

3. What's one thing about caring for my body that I need to do better?
 not overworking and better sleep

4. To honor God with my body over the next month, I am going to:
 be more intentional with sleep

5. A scripture verse I am going to commit to remember and store in my heart this month is: Matthew 11:28 NLT

"Then Jesus said, 'Come to me, all of you who are weary and carry heavy burdens, and I will give you rest. "

"*Consistency, not speed, is the key to this adventure. What grows through the slow and steady practice of meditation and memorization is a truth anchor that holds even in the fiercest of storms.*"

- Alicia Britt Chole[7]

How to SOAP

You'll need three items Bible + Pen + Journal to SOAP each day.

S - Scripture

Each week the key verse is noted at the top of your page in a specific version. In the S box, write out the verse. Writing has been known to aid in memorization, so this practice helps you in your efforts to store God's Word in your heart.

O - Observation

What are your observations about this verse? What stands out to you? If you're not sure, pause here and meditate on the verse. Invite the Holy Spirit to help you see what He's desiring you to see.

A - Application

What is the personal application of this verse to you? What is God speaking to you through the verse? How can you apply this verse to your life or upcoming week?

P - Prayer

Pray. Pray the verse itself. Ask God what He wants you to pray, He's ready to speak to you (Jeremiah 33:3). Pause, be still and listen. Take notes on what you feel or think in your spirit in the box here. You can also write out your prayer in the box, in case you want to revisit it again another day.

Verses and Resources for caring for our bodies:

Over the next 4 weeks, spend one day a week walking through a SOAP for the following verses...

"Do you not know that your body is the temple (the very sanctuary) of the Holy Spirit Who lives within you, Whom you have received [as a Gift] from God? You are not your own, You were bought with a price [purchased with a preciousness and paid for, made His own]. So then, honor God and bring glory to Him in your body." 1 Corinthians 6:19-20 AMPC

S Do you not know that your body is the temple (the very sanctuary) of the Holy Spirit Who lives within you, Whom you have received (as a Gift) from God? You are not your own, You were bought with a price (purchased with a preciousness and paid for, made His own). So then, honor God and bring glory to Him in your body.

- 1 Corinthians 6:19-20 AMPC

O The Holy Spirit is a gift that God has given us to help us be closer to Him. Don't neglect where it comes from. We were also bought, but we are not slaves. We are simply asked to bring glory to God in what we do.

A I want to bring honor and glorify God in everything I do and say, especially with the girls. I want to remind them that the things I say are because of God, not me.

P I pray that I will resemble God's child in His kingdom. I pray that, even when I'm not thinking about it, I will do and say what others need and that I'll be a vessel that God is proud of and can use.

"Now if Joshua had succeeded in giving them this rest, God would not have spoken about another day of rest still to come. So there is a special rest still waiting for the people of God. For all who have entered into God's rest have rested from their labors, just as God did after creating the world. So let us do our best to enter that rest. But if we disobey God, as the people of Israel did, we will fall."
Hebrews 4:8-11 NLT

S

O

A

P

Week 3

"'Are you tired? Worn out? Burned out on religion? Come to me. Get away with me and you'll recover your life. I'll show you how to take a real rest. Walk with me and work with me—watch how I do it. Learn the unforced rhythms of grace. I won't lay anything heavy or ill-fitting on you. Keep company with me and you'll learn to live freely and lightly.'"
Matthew 11:28-30 MSG

S

O

A

P

Week 4

"Beloved friends, what should be our proper response to God's marvelous mercies? I encourage you to surrender yourselves to God to be his sacred, living sacrifices. And live in holiness, experiencing all that delights his heart. For this becomes your genuine expression of worship." Romans 12:1 TPT

S

O

A

P

reflection

Use this page to capture any heart thoughts, visions, or dreams that are stirring in your spirit. Write it down in agreement with what He's speaking to you through your willingness to rest and make space for Him.

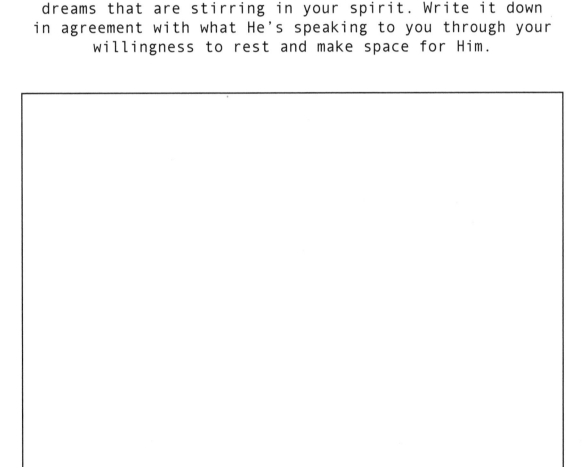

"The Bible is not an option; it is a necessity. You cannot grow spiritually strong without it."

-Billy Graham [8]

This month, let's discuss what the Bible says, and what Jesus modeled about caring for the mind.

Bible

"You must catch the troubling foxes, those sly little foxes that hinder our relationship. For they raid our budding vineyard of love to ruin what I've planted within you. Will you catch them and remove them for me? We will do it together." Song of Songs 2:15 TPT

When it comes to your mind, what are your troubling foxes? What hinders your relationship with Father? Do you struggle with self-deprecating thoughts? Do you wrestle with comparison? Is it unbalanced devotion to your job or a side-hustle? Is it a misperception of Father, His heart, and His ability? Do you people-please to the point of exhaustion, leaving nothing for yourself and perhaps not even a little for your family?

If you see a Wonder Woman, I assure you that if not already, before long she will be a worn out woman. We are so connected and surrounded by technology that our minds are being flooded at all times, from all directions. No wonder in recent decades we are an exhausted, anxious, and a fearful people.

As Jo Saxton stated during an IF:Gathering, there are voices everywhere telling us we're "too much, not enough, we're always, or we'll never be..."[9] We simply must turn and tune our minds into what God is saying to us, store His Truth into our minds, and meditate on what He says over us. It is in His Light and His Truth that we can find stillness and rest. We can empty ourselves before Him, and allow Him to fill us new, again.

1. What does the Bible say about caring for our minds?

2. How can we be intentional in caring for our minds?

3. What's one thing about caring for my mind that I need to do better?

4. To honor God with my mind over the next month, I am going to:

5. A scripture verse I am going to commit to remember and store in my heart over the next 2 weeks is: Philippians 4:6-7 NLT, and then I will meditate upon and memorize Isaiah 26:3 NKJV over the following 2 weeks.

"Don't worry about anything; instead, pray about everything. Tell God what you need, and thank him for all he has done. Then you will experience God's peace, which exceeds anything we can understand. His peace will guard your hearts and minds as you live in Christ Jesus." Philippians 4:6-7 NLT

"You will keep him in perfect peace, Whose mind is stayed on You, Because he trusts in You." Isaiah 26:3 NKJV

"One of the most effective ways of influencing our minds is through memorizing scripture. David said, 'I have hidden your word in my heart that I might not sin against you'."

- Jerry Bridges[10]

How to SOAP.

You'll need three items Bible + Pen + Journal to SOAP each day.

S - Scripture

Each week the key verse is noted at the top of your page in a specific version. In the S box, write out the verse. Writing has been known to aid in memorization, so this practice helps you in your efforts to store God's Word in your heart.

O - Observation

What are your observations about this verse? What stands out to you? If you're not sure, pause here and meditate on the verse. Invite the Holy Spirit to help you see what He's desiring you to see.

A - Application

What is the personal application of this verse to you? What is God speaking to you through the verse? How can you apply this verse to your life or upcoming week?

P - Prayer

Pray. Pray the verse itself. Ask God what He wants you to pray, He's ready to speak to you (Jeremiah 33:3). Pause, be still and listen. Take notes on what you feel or think in your spirit in the box here. You can also write out your prayer in the box, in case you want to revisit it again another day.

Verses and Resources for caring for our minds:

Over the next 4 weeks, spend one day a week walking through a SOAP for the following verses...

Week 1

"Do not fret or have any anxiety about anything, but in every circumstance and in everything, by prayer and petition (definite requests), with thanksgiving, continue to make your wants known to God. And God's peace [shall be yours, that tranquil state of a soul assured of its salvation through Christ, and so fearing nothing from God and being content with its earthly lot of whatever sort that is, that peace] which transcends all understanding shall garrison and mount guard over your hearts and minds in Christ Jesus. For the rest, brethren, whatever is true, whatever is worthy of reverence and is honorable and seemly, whatever is just, whatever is pure, whatever is lovely and lovable, whatever is kind and winsome and gracious, if there is any virtue and excellence, if there is anything worthy of praise, think on and weigh and take account of these things [fix your minds on them]. Practice what you have learned and received and heard and seen in me, and model your way of living on it, and the God of peace (of untroubled, undisturbed well-being) will be with you." Philippians 4:6-9 AMPC

S

O

A

P

Week 2

"Don't shuffle along, eyes to the ground, absorbed with the things right in front of you. Look up, and be alert to what is going on around Christ—that's where the action is. See things from His perspective."
Colossians 3:2 MSG

S

O

A

P

Week 3

"Let the morning bring me word of your unfailing love, for I have put my trust in you. Show me the way I should go, for to you I entrust my life." Psalm 143:8 NIV

S

O

A

P

Week 4

"For though we walk in the flesh, we do not wage war according to the flesh. For the weapons of our warfare are not fleshly but powerful through God for the tearing down of strongholds. We are tearing down false arguments and every high-minded thing that exalts itself against the knowledge of God. We are taking every thought captive to the obedience of Messiah—" 2 Corinthians 10:3-5 TLV

S

O

A

P

reflection

Use this page to capture any heart thoughts, visions, or dreams that are stirring in your spirit. Write it down in agreement to what He's speaking to you through your willingness to rest and make space for Him.

"Connection with God is the foundation for every other God-given tool we have to fight with. We begin here because if supernatural change is what we want, we have to go to our supernatural God to find it."

-Jennie Allen [11]

re

is a weapon.

\- Jonathan David Helser[12]

This month, let's discuss what the Bible says, and what Jesus modeled about caring for the soul (heart).

Bible

"Dear friends, I urge you, as foreigners and exiles, to abstain from sinful desires, which wage war against your soul." 1 Peter 2:11 NIV

There is an all out war for your soul.

The devil is real, but we know from the holy Word of God that he's defeated. Still, we cannot be ignorant to the reality that there is a very real spiritual battle and enemy that seeks to kill, steal, and destroy (John 10:10). In 2 Corinthians 10:4 we are reminded that the weapons we fight with are not weapons of this world. The weapons He has given us have POWER to demolish strongholds!

Our weapons - prayer, worship, faith, fighting the enemy with God's Word just like Jesus did, the armor of God - are in and of Him, and therefore, they are indestructible! WOW! I love this verse from Romans, too..."No, in all these things we are more than conquerors through Him who loved us." (Romans 8:37 NIV)

Bianca Olthoff said, "A conqueror can never win if a conqueror never fights".[13] Show up to this battle; you have everything you need in Jesus and the Word. Follow how He does things. He fought the devil in the desert with the Word of God (Luke 4:1-13). When He was overwhelmed, He retreated to a quiet place to get alone with God. He is Peace, Himself. Still, He knew time with Father was the perfect recharge station. While He was fully God, He was still also fully man. He understood that Sabbath is holy, prayer is mighty, and rest is necessary. Jesus had zero doubt in the integrity and ability of Father, and because He knew exactly who Father is, He was strong, confident, and wise in navigating this world.

One of the best ways to care for your soul (heart) is to go to Father in prayer, just like Jesus did. Maybe you still doubt the power of your prayers. Can I encourage you today to remember that your heart was created by the Creator, and He created your heart to know the voice of Holy Spirit? Just pray, sister. Just pray whatever you can muster as if you were talking to your best friend. Talk to Him, and watch Him war on your behalf. And guard your heart, guard what you allow to enter into it through your ears, eyes, mouth, and see how He fills you with faith and courage. He wants to build you up, and send you out.

Open up, and let His light in.

"Listen carefully, my dear child, to everything that I teach you, and pay attention to all that I have to say. Fill your thoughts with my words until they penetrate deep into your spirit. Then, as you unwrap my words, they will impart true life and radiant health into the very core of your being. So above all, guard the affections of your heart, for they affect all that you are. Pay attention to the welfare of your innermost being, for from there flows the wellspring of life." Proverbs 4:20-23 TPT

1. What does the Bible say about caring for our soul (heart)?

2. How can we be intentional in caring for our soul?

3. What's one thing about caring for my soul that I need to do better?

4. To honor God with my soul over the next month, I am going to:

5. A scripture verse I am going to commit to remember and store in my heart this month is: Proverbs 4:23 NLT "Guard your heart above all else, for it determines the course of your life."

"Sabbath is us agreeing with God that He is working while we stop; it's trusting that His heart and mission is always advancing, even when we are still. Scripture says be still and know that I am God not just because we need rest, but also because when we stop striving we remember His faithfulness."

-Shelley Giglio[14]

How to SOAP.

You'll need three items Bible + Pen + Journal to SOAP each day.

S - Scripture

Each week the key verse is noted at the top of your page in a specific version. In the S box, write out the verse. Writing has been known to aid in memorization, so this practice helps you in your efforts to store God's Word in your heart.

O - Observation

What are your observations about this verse? What stands out to you? If you're not sure, pause here and meditate on the verse. Invite the Holy Spirit to help you see what He's desiring you to see.

A - Application

What is the personal application of this verse to you? What is God speaking to you through the verse? How can you apply this verse to your life or upcoming week?

P - Prayer

Pray. Pray the verse itself. Ask God what He wants you to pray, He's ready to speak to you (Jeremiah 33:3). Pause, be still and listen. Take notes on what you feel or think in your spirit in the box here. You can also write out your prayer in the box, in case you want to revisit it again another day.

Verses and Resources for caring for our soul:

Over the next 4 weeks, spend one day a week walking through a SOAP for the following verses...

Week 1

"Feed the hungry, and help those in trouble. Then your light will shine out from the darkness, and the darkness around you will be as bright as noon. The Lord will guide you continually, giving you water when you are dry and restoring your strength. You will be like a well-watered garden, like an ever-flowing spring. Some of you will rebuild the deserted ruins of your cities. Then you will be known as a rebuilder of walls and a restorer of homes. 'Keep the Sabbath day holy. Don't pursue your own interests on that day, but enjoy the Sabbath and speak of it with delight as the Lord's holy day. Honor the Sabbath in everything you do on that day, and don't follow your own desires or talk idly. Then the Lord will be your delight. I will give you great honor and satisfy you with the inheritance I promised to your ancestor Jacob. I, the Lord, have spoken!" Isaiah 58:10-14 NLT

S

O

A

P

Week 2

"Yes, I must find my rest in God. He is the God who gives me hope." Psalm 62:5 NIRV

S

O

A

P

Week 3

"Why are you cast down, O my soul, and why are you in turmoil within me? Hope in God; for I shall again praise him, my salvation and my God." Psalm 42:11 ESV

S

O

A

P

"The LORD is my strength and my [impenetrable] shield; My heart trusts [with unwavering confidence] in Him, and I am helped; Therefore my heart greatly rejoices, And with my song I shall thank Him and praise Him. The LORD is their [unyielding] strength, And He is the fortress of salvation to His anointed." Psalm 28:7-8 AMP

S

O

A

P

reflection

Use this page to capture any heart thoughts, visions, or dreams that are stirring in your spirit. Write it down in agreement to what He's speaking to you through your willingness to rest and make space for Him.

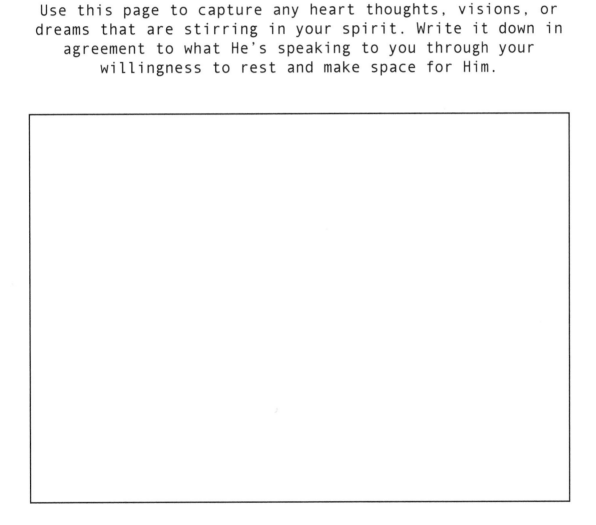

"Replace what you don't know about the future with what you do know about God."

- Christine Caine[15]

In music, a rest is described as a defined period of silence, a quiet space with rhythmic purpose.

"As Jesus and the disciples continued on their way to Jerusalem, they came to a certain village where a woman named Martha welcomed him into her home. Her sister, Mary, sat at the Lord's feet, listening to what he taught. But Martha was distracted by the big dinner she was preparing. She came to Jesus and said, 'Lord, doesn't it seem unfair to you that my sister just sits here while I do all the work? Tell her to come and help me.' But the Lord said to her, 'My dear Martha, you are worried and upset over all these details! There is only one thing worth being concerned about. Mary has discovered it, and it will not be taken away from her.'" Luke 10: 38-42 NLT

Mary chose the good thing. In a Martha world, Mary chose to gaze at God in flesh. Emanuel. Jesus.

Did you catch that last part? Mary chose the good thing that will not be taken away from her. Choosing time with Jesus is time that is well spent and can never be stolen. Sure there are things to be done, but we don't want to prioritize it all above Jesus. People "of the world" can easily understand and even get behind the kindness and benevolence of Christians... what the world doesn't understand is when we choose worship and time seeking our Savior's face. That's foreign and weird to them. Exuberant and/or reverent worship expression is considered very weird. Tithing? Crazy! We are called to emulate the supernatural. Therefore, we won't make sense to the natural mind. We are drawn to more... more of Him. The more we taste and see that He is good (Psalm 34:8), the more we will crave to go deeper.

There's a drawing to Jesus within us. As CS Lewis describes it: "If I find in myself a desire which no experience in this world can satisfy, the most probable explanation is that I was made for another world."[16]

We have been intricately designed by the creator of the universe, and temporarily have this time and space here on earth. God designed us in such a way that music moves us. It speaks to us. It amplifies and changes and infiltrates our very moods. And even more, repetition affects what we think about and meditate on. If you do not currently listen to worship music regularly, start increasing your exposure to worship music. Perhaps during a commute to work or when you're out for errands, begin listening to worship music somewhere near the start of your day.

Do this for 2-4 weeks and consider journaling your thoughts. Watch how putting God-centered songs into your mind and heart influence how you perceive your day and your Father. At the end of the 2-4 weeks, I challenge you to invite a friend for food or coffee and tell them about your experiment. Help others see the power of worship in their lives.

Want to level up? Spend time in worship on your own. If you can create a routine, great! But if not, start small with some of these ideas:

Singing along in your car to a worship song; taking communion at your table before your household awakes and your day begins; praying and meditating on the goodness of God; sitting in quiet thankfulness; praise dancing alone in your home!

Whatever worship looks like for you - give an offering to Father of your gratitude and acknowledgment of His sovereignty in your life and His great kindness and love.

Are you facing a battle? Worship is a weapon, my friend!

"My weapon is a melody"

– Bethel Music[17]

Have you ever heard

that lyric in the song, "Raise a Hallelujah"? It's a powerful declaration, and Jonathan and the other writers know their Bible and the power of worship. You can read stories in the Old Testament (2 Chronicles 20:21-22) where worshippers lead at the front of the battle - that's a crazy strategy. But in God's economy, the supernatural will never make sense to the natural mind. If only we could see the battle He's winning for our souls all around us. I like to imagine a power that lights up the supernatural sky when we lift our voices in worship (battle) declaring Him as our forever King! I like to imagine Him rushing in like King David described in Psalm 18:1-19.

Just as God told Jehoshaphat the battle was not theirs, friend, your battle is also His. We must keep ourselves in His full armor ready to fight! Sometimes, we just need to show up, worship, and trust Him to slay our foes, and sometimes that looks like sitting quietly at rest at His feet.

It's all His. And if you're trusting Him, you are always on the right track.

"You will keep in perfect peace all who trust in you, all

Peace and hope in Christ,
- Amy

Want to
read more?

The Psalms are filled with songs of worship.

Here are a few to get you started:

Psalm 13:5-6 NLT
Psalm 23 NIV
Psalm 105:1-4 AMPC
Psalm 108:1-5 NIV
Psalm 131:1-2 TPT
Psalm 130:5 ESV

Consider reading through the entire book of Psalms. Set a timeline that is reasonable for you in your season, and start your day with these heart songs to God. Take in the vulnerability of the writers and see how it's okay to bring Him your anger, pain, and grief in addition to your adoration, love, and praise.

He wants all of you.

✛ Written by: Amy Eaton

To God be all honor and glory for anything special about this study book in your hands. He planted it all in my heart and it would not exist without His guidance and care. I'm so deeply thankful He led me on a journey to stillness and closeness with Him. What a privilege it has been to help bring this book to you and encourage you to draw closer, too.

✛ Edited by: Mytra Layne

To Mytra, thank you for listening to the nudges of Holy Spirit, and your obedience to His call and gifts of editing. You are a gift, and I pray He bless you for your kindness. Thank you for helping me with clarity and using your gifts and passions to serve Him. Love you!

✛ Designed by: Nani Williams

To Nani, you have walked through this vision with me fully, and I am so humbly grateful. I pray the Lord bless you for your generosity and kindness. Thank you for saying "yes" to Him as He whispered to you, and being a willing heart. Thank you for using your gifts to honor Him. You make the world a more lovely place with your artistry and excellence. Love you!

REST

References:

1. P31OBS. Quote from Jenn Rothschild. Instagram, Jennifer Rothschild, 15 Oct. 2019, https://www.instagram.com/p/B3qBQVwg-fc/?igshid=nojwoamkg40a.

2. RuthChouSimons. Quote in caption by Ruth. Instagram, Ruth Chou Simons, 29, Dec. 2019, https://www.instagram.com/p/B6roW2TAo7u/?igshid=fbboossr9gp7.

3. Spurgeon, C. H. "How to Read the Bible by C. H. Spurgeon." The Spurgeon Archive, accessed 8 Feb. 2020, archive.spurgeon.org/sermons/1503.php.

4. "G373 - Anapauō - Thayer's Greek Lexicon τινά." Blue Letter Bible, 2020, www.blueletterbible.org/lang/lexicon/lexicon.cfm?Strongs=G373&t=KJV.

5. Voskamp, Ann. "Sticky Notes for the Soul [Sign Up]." Ann Voskamp, 2014, annvoskamp.com/sticky-notes-signup/.

6. Hesterly, Danny. "The God Who Speaks, Speak to Us." City Church Sunday Sermon. City Church Sunday Sermon, 25 Aug. 2019, Chattanooga, TN.

7. Alicia Britt Chole, Anonymous: Jesus' Hidden Years ... and Yours (Nashville TN: W Publishing Group, an imprint of Thomas Nelson, 2011), 83.

8. Billy Graham, The Journey: Living by Faith in an Uncertain World (Nashville TN: W Publishing Group, an Imprint of Thomas Nelson, 2006), 111.)

Continued:

9. Jo Saxton. "Run Free – Romans 8:14-17." If Gathering 2020, 8 Feb. 2020, Livestream. live.ifgathering.com.

10. Jerry Bridges, The Pursuit of Holiness (Colorado Springs, CO: Nav Press, 2006), 67.

11. Jenny Allen, Get Out of Your Head (Colorado Springs, CO: Water brook, an imprint of Random House, 2020), 79.

12. Helser, Jonathan. "Rest Is a Weapon." Jonathan David & Melissa Hels er, 9 Oct. 2018, www.jonathanhelser.com/blog/2018/10/9/rest-is-a-weapon.

13. Biance Olthoff. "More Than Conquerors – Romans 8:31-37." If Gathe ring 2020, 8 Feb. 2020, Livestream. live.ifgathering.com.

14. ShelleyGiglio. Quote in caption by Shelley. Instagram, Shelley Giglio, 17 Sept. 2019, https://www.instagram.com/p/B2hV4I JFfjl/?igshid=14z1rewzq362i.

15. TheChristineCaine. Quote from status post by Christine. Facebook, Christine Caine, 21 Dec. 2013, https://www.facebook.com/theChris tineCaine/posts/replace-what-you-dont-know-about-the-fu ture-with-what-you-do-know-about-god/10153649145650089/.

16. C. S. Lewis, Mere Christianity (New York, NY: Harper Collins, 2001), 136-137.

17. Bethel Music. "Raise a Hallelujah." Victory, Bethel Music Publishing, 2018, https://bethelmusic.com/chords-and-lyrics/raise-a-hallelujah/.

CPSIA information can be obtained
at www.ICGtesting.com
Printed in the USA
LVHW071030040121
675645LV00003B/62